From the beginning, the Turner Prize's purpose was to 'widen interest' in contemporary art in Britain. With hindsight these seem modest words. Since the prize was set up in 1984, to be awarded annually to a British artist for an outstanding exhibition or presentation of their work from the preceding year, the public profile of contemporary art has increased phenomenally, and the Turner Prize has proved a highly effective vehicle for stimulating interest, and occasionally controversy, around the art of today. But this of course would not have been possible were it not for the sheer strength and diversity of British art.

The issues art addresses and the forms it takes have changed enormously over the past three decades. While the artists are nominated on their own terms, and this year's shortlisted artists are as varied as ever, there are certain common interests: much of the work is sculptural, albeit diverse in character and incorporating other mediums; much of the work references other areas of visual culture such as advertising, design, fashion and the built environment; the work often reflects and assumes the growing ubiquity of the internet in all areas of life; and there is a strong and probably related interest in comparing how written and visual language convey meaning (or fail in doing so).

Now in its 32nd year, we are delighted to welcome back the Turner Prize to Tate Britain to present the work of four exciting artists. We are grateful to many for their contribution to the exhibition, and this accompanying publication, but I would especially like to thank the members of the jury – Michelle Cotton, Tamsin Dillon, Beatrix Ruf and Simon Wallis – for their thoughtful approach to shortlisting this year's artists; Linsey Young, Curator of Contemporary British Art at Tate, for taking the curatorial lead, together with Laura Smith, Exhibitions and Displays Curator; our colleagues across Tate for their many, varied contributions to the project's success; the artists' representatives and lenders of works to the exhibition; and most of all, Michael Dean, Anthea Hamilton, Helen Marten and Josephine Pryde for their commitment and inspiring work highlighted in the 2016 Turner Prize.

Alex Farquharson
Director, Tate Britain

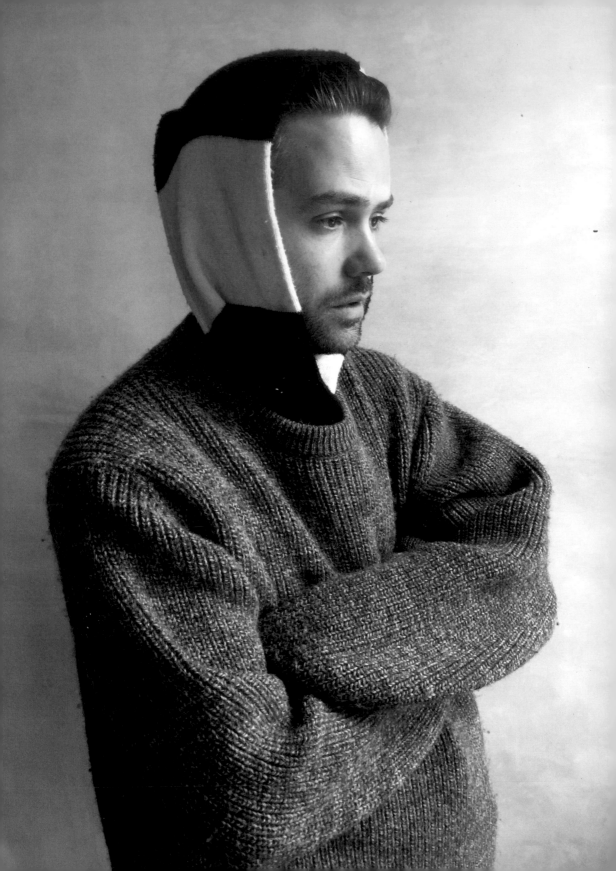

MICHAEL DEAN

'All shores describe touching.'[1]

Michael Dean's work begins with writing. In sculpture, photography and performance he gives physical form to his own texts, abstracting and distorting his words into an alphabet of human-scale, anthropomorphic forms. He has created a lexicon of his own making, a series of three-dimensional glyphs made out of concrete, steel reinforcement, soil and sand, corrugated sheet metal and chain link fence. This makes allusions to bodily elements like tongues, hands, limbs and eyes – abstract compositions that encourage a curious empathy.

Dean is interested in the potential of words to be expressed in material form. Early in his career, the main component of his work was his writing, manifest as short texts, self-published books, sentences and dialogues alongside small configurations of found objects and photography arranged almost grammatically – like words in a sentence. In recent years, however, his sculptures have become larger and more self-assured – one could say, words set in stone. Dean produces these works by translating excerpts of his writing into a typeface of his own design, from which he then generates moulds and casts. If we imagine each of Dean's works as a word, then their composition could be read as syntactical: each part of his sculptures or installations becomes a constituent element in the physical sentences and phrases he arranges. That said, the significant factor is not that the sculptures are decipherable as words,

but rather that a viewer –
or reader – should be able to
faintly discern language in their
forms, that a word or an idea
should be just about imaginable.
As such the sculptures invite
us to engage with them on a more
individual level, and become
spaces through which to explore
subjectivity in language and art.

Using materials that are
instantly recognisable from the
rawer spaces of manufacturing and
the built environment – concrete,
steel, anti-vandal paint, cor-
rugated metal – Dean's objects
appear as though they could have
wandered in from a docklands,
a building site, or an industrial
estate. He displays a heightened
sensitivity to his materials'
physical properties, playing
with steel's propensity to rust
for example, or more specifically
the malleability and familiarity
of corrugated sheet metal.
Perhaps most significantly,
he manipulates the porosity of
concrete – a material that, even
when set, can be stained by its
environment, absorbing leaks
and drips and the traces of human
touch. This choice of materials
and way of working endows Dean's
sculpture with a sense that it
is both organic and manmade. His
peculiarly anthropomorphic forms
seem to be encrypted with dormant
or latent meaning, waiting to
be awoken or decoded by their
viewers/readers, much as children
find significance in the most
abstract of things and materials.

Dean received his Turner Prize
nomination for his exhibitions
Sic Glyphs at the South London
Gallery and *Qualities of
Violence* at de Appel arts centre,
Amsterdam, both of which are
represented in his Turner Prize
exhibition. For *Sic Glyphs* Dean
presented, in a glaringly white
gallery space, an entire alphabet
of concrete barricades, lumpen
steel figures, metal wire and
corrugated panels, together
with clumps of earth, decaying
weeds, seaweed, and casts of
the artist and his wife and sons'
pointing and contorting fists.
Made to enter through the back
door (the gallery's main entrance
was blocked by a sculpture),
visitors to the exhibition were
plunged into an expanse of heavily
abstracted symbols, described by
Dean as 'a typographical texty
field or a fucking forest of
physically abstracted versions of
my writing.'[2] Although no specific
direction through the works was
given, there was the sensation
that visitors' movements were
being somehow choreographed
within the arrangement of sculp-
tures in the space. It was as
if each viewer/reader became
a protagonist in the work,
reinforcing Dean's intention,
expressed in the exhibition's
guide, that it matters that it
is *you* who walks in through the
door – that you are so much more
than simply a reader of *his* text.

Language in its more conven-
tional form did make an appearance

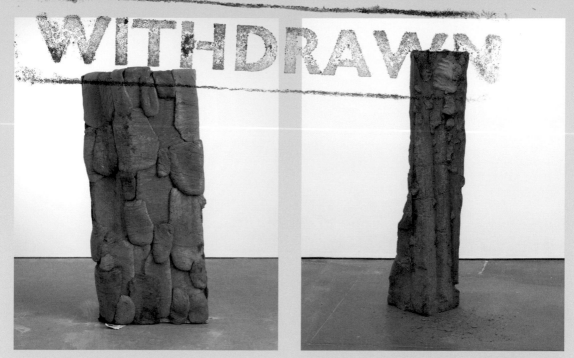

nownow (Working Title) 2015 *now (Working Title)* 2015

throughout the exhibition as
a series of stickers displaying
variations of the word 'shore'
('sho', 'shores', 'shoring',
'shor', '4 sho', 'shorings',
'shore 4', 'shored'), which pep-
pered the edges of the exits and
the entrances of the gallery as
well as the sculptures themselves.
Made to look like the promotional
stickers we see on shop-front
roller shutters all over London,
these signs played on at least
three possible definitions of
the word: 1. A liminal site where
two elements touch; 2. A prop
or beam which holds something up,
or supports it; 3. 'To be sure'
('sho'), certain or secure. With
this in mind, then, Dean's sculp-
tural alphabet seemed to encour-
age – or support – language's own

elasticity and liminality, exag-
gerated here through its physical
abstraction and arrangement.
 For *Sic Glyphs*, Dean also
created a new book, *fffff
(unfinished notes)*, which
appeared to have been made with
a computer software's spraygun
tool: clip-art symbols of
cannabis leaves, machine guns,
pennies, Bob Marley's face, rain
clouds and hermaphrodite Playboy
bunnies trace the typographical
loops and swirls of Dean's text,
dancing across the page with
little regard for the margins or
gutter, or indeed legibility. The
book also made minor appearances
throughout the exhibition in
various precarious circumstances
– supporting a concrete limb,
crumpled atop an industrial

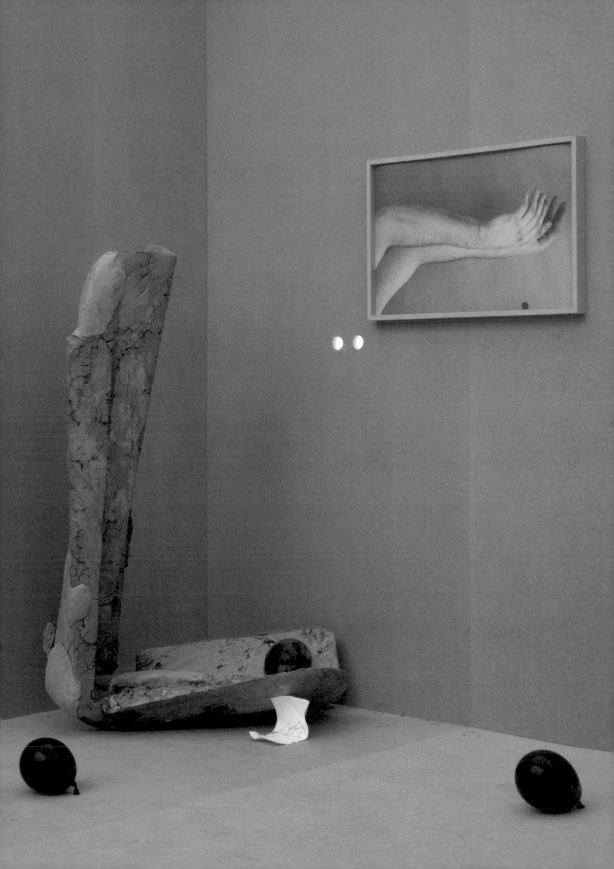

arm, protruding from cracks, or littering the floor. It was as though the sculptures had literally shed the language that produced them.

Qualities of Violence at de Appel arts centre contained many similarly constructed sculptures, though this time they were more sparsely arranged in a series of rooms clad in raw MDF, almost as figures waiting to greet (or, perhaps, ward off) visitors in an eerily charged sequence. The most striking part of this presentation was Dean's *(United Kingdom poverty line of Sixteen thousand seven hundred pounds sterling translated at an exchange rate of 1.27 on Christmas day 2014 into two million one hundred and twenty thousand nine hundred euro cents.)* 2015, which consisted of £16,700 – the then UK poverty threshold for a family of four – converted into 2,120,900 individual euro cent coins: an emotive quantity made physically apparent. The coins covered the floor like a smelly metallic scree that visitors were invited to walk on, implicating all who stepped on the coins in a shrewd questioning of value within the art world and, more widely, of how wholly democratic access to the arts really is.

Dean's work contrasts the latent language of functional, often industrial, materials with the more purposefully communicative, usually immaterial realm of written language. His handmade

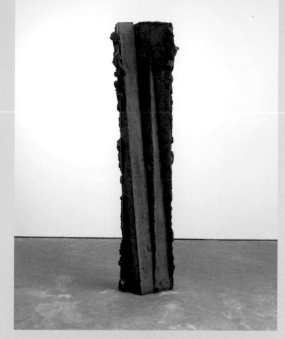

now (Working Title) 2015

abstract alphabets draw the viewer into a physical way of reading, which involves moving around and through his textual field. Dean is present just enough to bring the work into being, before making himself, as any sort of autonomous author, absent so that we can find our own meanings among his taciturn figures. His work not only resists containment but, moreover, celebrates the subjective sovereignty we may get from the elasticity of language – an elasticity that Dean makes manifest in the physicality of his work and the way it engages both our minds and bodies. LS

Opposite: *Qualities of Violence*, installation view, de Appel arts centre, Amsterdam 2015

7

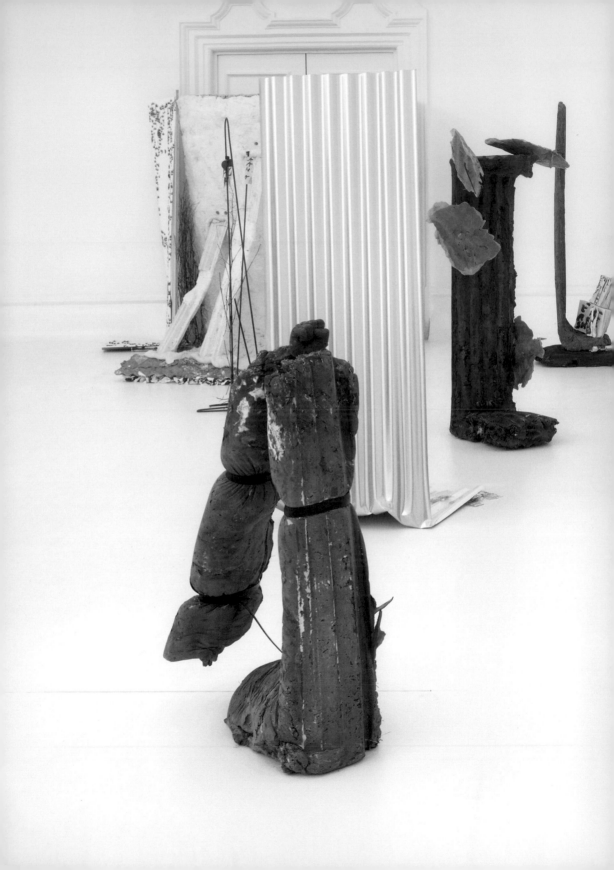

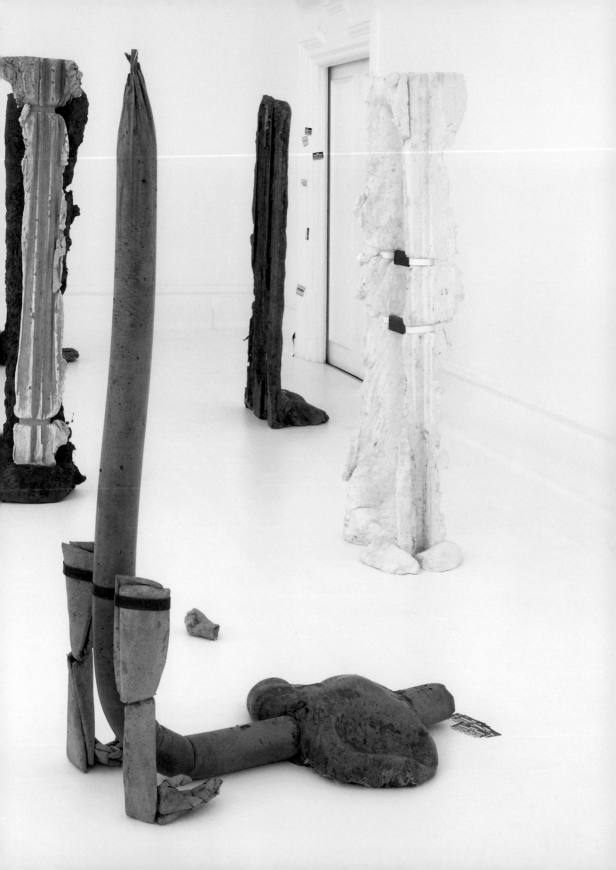

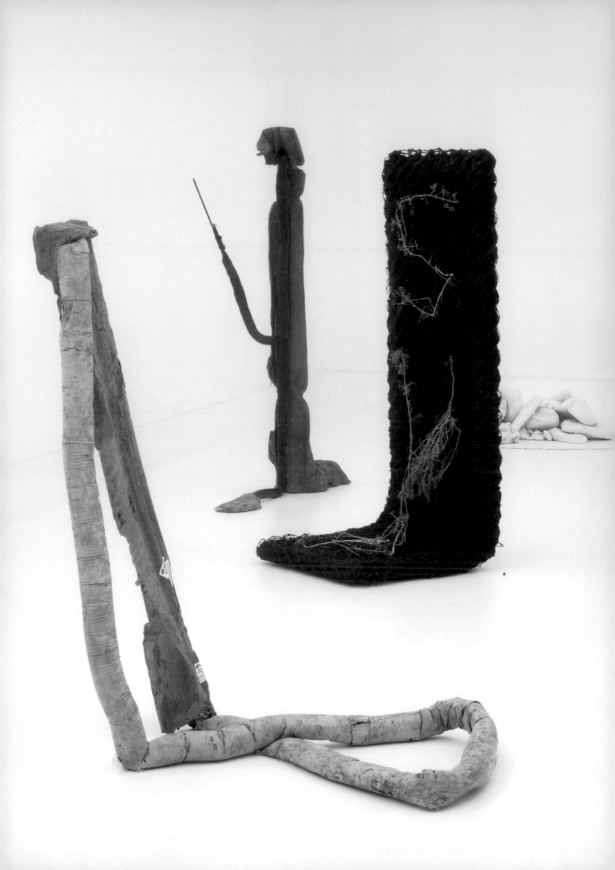

All interviews are in the artists'
own words and have not been edited
by Tate.

LINSEY YOUNG I'm interested in
your relationship with Newcastle
upon Tyne. How does the city
feed into the work – or maybe
it doesn't at all?

MICHAEL DEAN It's there in the
fabric of the work, but it's
difficult to talk about.

LY I guess I'm thinking
about politics, because I know
that's something we're both
interested in...

MD There's the politics of
intimacy then, and the politics
of resistance.
 FFFF! Why should it be
so difficult to talk about
Newcastle because it's in
everything I do? It's in the
materials I put to use, it's in
the size of the experiences I'm
trying to convey, it's the chip
on me shoulder, the politics,
the bravery and cowardice that
comes with a history of poverty.
 There was a sense of things
being left behind in Newcastle,
and growing up in the 165
estate where you have a series
of concrete brick housing
cells that look completely
the same, and it's only through
palimpsestic sense that one
can begin to differentiate
and negotiate the geography
of the place. You know oldboy

Fred lives by the painted
corner and that caravan's burnt
out diagram of my ch chchav
angst signifies one cell left
until the off-licence. And this
idea that all of the things
people leave behind and how we
transcribe the hyper-authorial
evidence of late one night,
early one morning.
 The idea of post-human like,
growing up in Blakelaw, the
llliterature of all our lllitter
all over this pit heap behind
the house that ghosts some
industrial history, an old
colliery where they took stuff
from under the earth and dumped
it in a field that now is a little
hill in this housing estate built
some hundred years after that...
hills and holes.

LY There's that sense of
Newcastle I have (which may
of course be incorrect) that
the autonomy of the people was
taken away, that industry was
wound down and it ripped the
heart out of communities.

MD I've seen and heard the
memories of that industry
but to be fair, that was long
gone... Ours was this industry
of poverty, ha ha ha ha.
I know, I know, get your
ffffing violins out; close
our libraries, our centres,

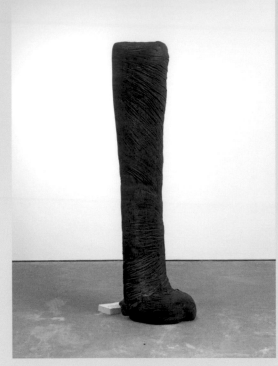

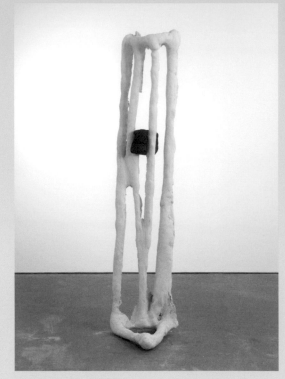

now (Working Title),
Diminishing book. (Not Titled) 2015

now (Working Title),
Analogue Series (muscle) 2015

our schools in exchange for
fields, eventually motorways
and gated communities. Ha ha.
All this becomes a flower of
resistance when, because of
a free dictionary given out
in a box of washing powder,
you find yourself using words
to hold all your intensities and
attractions together, and know
somehow simultaneously that there
is something called literature
out there but you just can't
ffffing find it! Ha ha. I think
at times I thought it was a
social experiment. What do
you get if you trap people in
an estate without access to
literature? Ha ha.

LY Your work is rooted in
a fascination with language.
I wonder if you could talk
about how it has grown from
being predominantly book, or
paper-based to a place where
the object, the physical or
sculptural manifestation of
language dominates?

MD Over years of producing all
of this material, all of this
writing, and it's just sitting
there as bits of thin biro on
paper. What does it do? How can
I get it into people's hands?
 When I'm stood standing writ-
ing in front of a burnt-out car
or a vandalised tree, I might

12

begin to graph the possibilities
of destruction and disappearance
in the burning, blacking blue,
a physical emoticon of young
hope broke in half. It's like
becoming intense at the sight
of stars. Who the ffff is
going to tell you differently?
The work should be read in the
same way that it was written.
I want to deliver my work into
an intimacy which is symmetrical
to the intimacy that gave origin
to the work.

Looking around then as
I am, thinking, 'in relation
to what have I been intense?'
I start taking pictures of urban
surfaces, thinking I can give
my writing a face. I take
photographs of trees by motor-
ways or lamb shoulder gone
desaturated grey and concrete
pavements upended here and
there around London. I can
print these photographs at
the supermarket. I can fold
them according to a typo-
graphical rule which renders
text a concertina glossy toss
of raking light, giving off
images of glyphy prisms doing
the urban surface. But I'm back
again at the image or the thin
of the print of the page. The
thin of the ink. There isn't
enough equivalence of presence
to these forms compared to
the intensities that conjured
intimacy.

So I'm printing out photo-
graphs at the supermarket
and folding them according

to the given typographical
rule, and then I take photos
of these photos with the light
highlighting the folded forms'
concertina glossy toss of
high-gloss prints. The step's
broken in our flat so I've got
some concrete to fix the step
because you can't have a dodgy
step when your wife's pregnant.
I mix cement and notice how it
works, like those ffffing punk
chords: this is a cement, this
is a sand, this is a water. Now
form a sculpture! Ha ha. Later
that night I'm raging over all
these images and jpegs and decide
to take concrete to this tossy
gloss. I reinforce the back
of the folded photograph with
sand and protect all £12.75
of the photograph with layers
of economy cling film.

When I flayed the parched
picture from the surface of
the newly formed stone I thought
I saw the word turned into the
world. I felt that finally an
equivalence was conjured and
that this cheap dusty diamond
with its economy cling film
wrinkles looked simultaneously
naturally formed and handmade.

Everything is failing and
falling, everything is broken
and in identifying those
materials which we all somehow
know and understand and that are
there, I feel like as the artist
I can evaporate just long enough
for them, for you, to feel like
it actually matters that you've
walked in through the door.

ANTHEA HAMILTON

In March 1975, in the weeks leading up to his untimely death, Italian director Pier Paolo Pasolini wrote a series of fourteen letters to the left-wing newspaper *Corriere*. These letters were addressed to a young Neapolitan man, Gennariello, and were intended as a guide to contemporary Italian life, to provoke political and social thought, and perhaps most importantly to build a love and respect for the proletariat heritage of Naples which Pasolini felt was under threat from the rise of the bourgeoisie and the post-War economic model known as 'neocapitalism'.[1] In one of these letters, Pasolini says he might be described <u>negatively</u> by 'a fascist lady, a young person from the extra-parliamentary movement, by a left-wing intellectual and a pimp'.[2]

Anthea Hamilton often identifies and focuses on short fragments of text that are unearthed during research, brief statements that come to encapsulate the thinking behind a body of work. Of late, this idea of Pasolini's has become one such reference. Pasolini's letter informs the Neapolitan boy that his mentor's viewpoint is not that of those people he might have come to listen to in bourgeois life, but that of an artist born from the working classes. In doing so he ruptures the status quo – or, as Hamilton describes it, 'creates holes, rather than a surface'. In other words, he offers the possibility of new ways of learning.

Research or learning is an integral part of Hamilton's practice. It holds a specific position, sitting parallel to the making of objects, video or performance, but

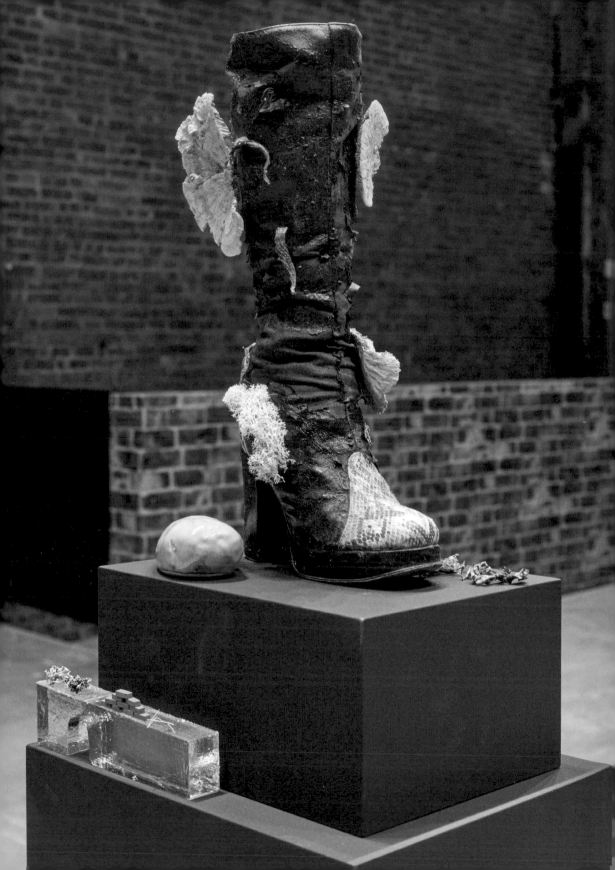

might yet remain hidden to the viewer. For example, lichenology – the study of perhaps the most humble of natural materials – informs much of the work in this exhibition, although lichen is physically present in only one work. However, as Hamilton has developed recent projects, close research of a subject has become less critical to her, heralding a shift from logic to experience. Where objects might previously have been brought together in formations that were self-contained and could be restaged or replicated, adhering to particular research methodologies, her interest currently is to pursue ways of re-generating sensations that might have nothing to do with the subject of the specific research that she had followed. Instead, this sensation might have everything to do with the way in which the light falls at a particular time of day, and the emotional response that it provokes. This shift can be recognised, for example, in the series of chastity belts that hang from the ceiling. Modelled on locks from the collection of the Metropolitan Museum in New York, the designs laser-cut into them are inspired by Hector Guimard's preparatory drawings for the Paris Metro, and particularly by a comment Hamilton discovered in one of Guimard's notebooks where he described his desire to invoke an image of what nature feels like rather than what it looks like.

Perversely for work that may have previously been read as capricious and responsive to popular culture, the recent shift in Hamilton's work can be articulated as a move away from a formal or linear understanding of the world around her to one that is more free-form and experiential. For Hamilton, this coincides with a move in her work towards new ways of looking – ways in which hierarchies are broken down and the pace of processing information has changed. One consequence is that we are not presented with athletic young bodies in leotards – as in *Gymnasium* (Chisenhale, London 2008) – nor seductive popular cultural icons such as John Travolta, as in *Sorry I'm Late* (Firstsite, Colchester 2012). Instead, in *Lichen! Libido! Chastity!* (SculptureCenter, New York 2015, and in this exhibition), we are asked to look at the brick walls, real and wallpapered, that cover the gallery, or static clouds in a mural of the late afternoon sky of London in June, to really look at the detail of our immediate environment. With the obvious exception of the giant nude backside, Hamilton's usual flexing or reclining bodies

Opposite:
Lichen! Libido! Chastity!, installation view, SculptureCenter, New York 2015

17

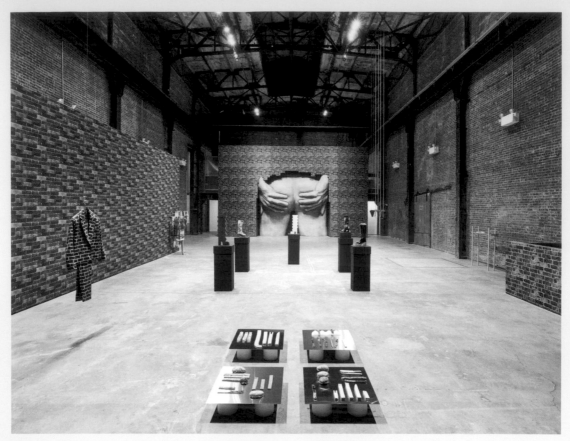

Lichen! Libido! Chastity!,
installation view, SculptureCenter, New York 2015

are notably absent: a series of
chastity belts hang empty, and a
suit made of bricks, pressed and
hung, awaits its owner's return.

That very large backside
(*Project for a Door (After
Gaetano Pesce)* 2016) is a
souvenir that Hamilton brought
back from her exhibition in
New York, as you or I might
bring back an 'I♥NY' t-shirt
or a Central Park snow globe:
an object that represents
an experience of the city.
Originally conceived by the
architect and designer Gaetano
Pesce in the 1970s as a proposal
for a doorway into an Upper
East side apartment building,
the idea lay dormant as a small
model in the designer's archive
until Hamilton realised it –
as a sculpture, not a functional
architectural feature – decades
later at the SculptureCenter.
In the intervening years,
Pesce's proposal, which had
always gestured towards issues
of class and how people navigate
a city, has taken on increased
significance: as curator Ruba
Katrib has highlighted, 'poor

18

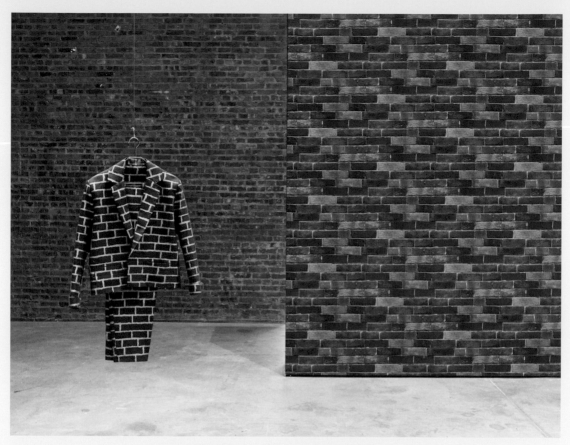

Lichen! Libido! Chastity!,
installation view, SculptureCenter, New York 2015

doors' – entrances to luxury apartment blocks that separate wealthy homeowners from workmen or social housing tenants – are now, sadly, commonplace in our capital cities.[3]

Project for a Door is a work that encapsulates many facets of Hamilton's practice and acts almost as a 'statement of conceptual intent'.[4] It deals with the body and the intellect, 'high' and 'low' references (the hierarchies of which she collapses), celebrated and obscure cultural precedents

(with latent potential in the present), and questions of spectacle and how we experience the world spatially and in terms of the language of images. Her work often presents itself in bold, direct ways, while playing with ambiguity and multi-layered meaning. Surrounded by her meticulously crafted and choreographed objects, we might be prompted to think anew on our own relationships to images and objects, and how that is expressive of our outlook on culture and society. LY

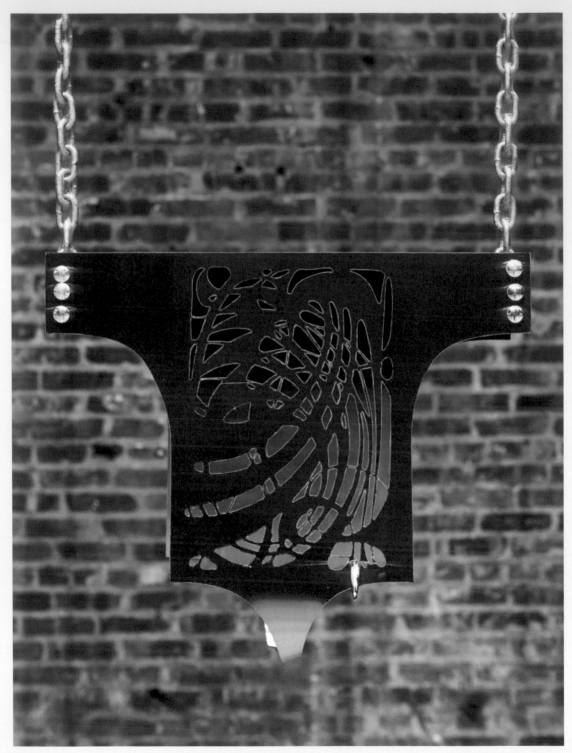

Lichen! Libido! Chastity!,
installation view, SculptureCenter, New York 2015

LINSEY YOUNG *Project for a Door* is a work that is very much rooted in New York. Can you talk a little about the process of re-making it and how it is being adapted for a UK context?

ANTHEA HAMILTON As direct as this work is, it does require some introduction. I've been a great admirer of the notable New York-based designer Gaetano Pesce's work for several years, and I'm always excited to share it with people through talks, studio visits and so on. His *Project for a Door* n.d. is a silicone mould: Gaetano Pesce has said that he was *curious* about this new material, and decided to experiment with it as a means to create a proposal for a building – it's ultimately quite pragmatic. *Project for a Door (After Gaetano Pesce)* is an homage to that playful attitude and it may galvanise opinion as it does in one-to-one conversation – sometimes you see the flicker die in someone's eye when I share the image of Gaetano's work with them. You're either with me for a spectrum of reasons, or you are not.

It requires no adaptation for re-making in London because it's the idea over and above the image. It's being remade but from the same 3-D scan as the original – a digital way of bringing New York with me that's in keeping with Pesce's commitment to new processes.

I normally work in response to a space. The bricks of the surround of Pesce's original *Project for a Door* were in harmony with the elegantly industrial architecture of the SculptureCenter, where it was shown. Transposing that fake brick into the extension built in 1979 is absurd, but why not?

It's part of a series of larger than life remakes: physical realisations of images from my archive that have driven my own curiosity. They include a blown glass table for making phone calls; *LET'S GO*, a large-scale mural framing a Robert Crumb drawing; and the performance *Kar-a-Sutra*, which used 'a cast of resident mimes to bring the archival images to life'[5]. All this comes from a key phrase, 'the physical knowledge of images', from Antonin Artaud's manifesto *No More Masterpieces* c.1926. And during my studies at the Royal College of Art I met the late Ellen Cantor who offered some simple and great advice – that to remake something is to get to know it better.

LY Disco seems to be a huge influence on you – its music, fashion and icons. You were born in 1978, at the later stages of disco's development; why do you think this historic, largely American movement has had such a strong influence on you?

AH Across the many strands of my practices, the root is study and then simulating modes of looking. What's interesting about the thread of research into disco is that it has provided different ways to look at things. The effects of the discotheque – with its sequenced lights, smoke machines and platform shoes – are overwhelming. Disco wilfully opted for a glam politicisation of the self: a cultural phenomenon that signified a reaction to the utopian dreams of modernism. It provided neither an alternative nor an endorsement. It can be seen as a geo-political event that could only have occurred at that point in history in New York; for the first time, the communities of blacks, Latinos and gays had a unifying platform without prejudice that encouraged personalised self-expression, whilst technological advances meant that high quality, sophisticated music could be produced and distributed by those without privileged access to expensive instruments. It's not so much about the dance moves, but the liberty bestowed to strut them.

Looking back to historical moments is not nostalgic, rather that they are normally fixed and quantifiable and therefore assessable. Disco is important, John Travolta I don't give a damn about. Disco, as an example, serves as a model for how current events, current things might play out and so it offers me systems for understanding alternative perspectives both visually and theoretically, an *education sentimentale* of sorts. The present is always a wild and raw psychedelic experience.

There is an openness to disco that is perhaps not so accessible (or explicit) in current works. These tastes are more personal: an expansion and contraction of practice. Just as the mass media culture machine used John Travolta's face to suppress the true voices and activists of the disco scene, that type of classically beautiful image is the empire upon which my practice is built. That use of pop iconography is at rest for now and it's a radical mannerist moment!

LY You've described the work in this show as having similarities to that of a seasonal fashion collection. Could you talk a little about the way in which you work with textiles and garments?

AH When I consider fashion it's more about the speed – the focus of effort, the communal processing of ideas that can turn out a couture collection in eight weeks and perhaps how that pressure forces a liberated look towards materials, fabrics, PVCs, leather... and to forms. It's texture hitting texture, using the human body as a frame. As much as strong impact is required, there isn't a necessity to remain static

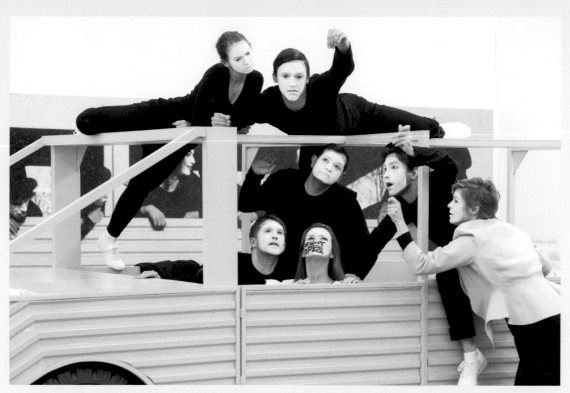

Kar-a-Sutra (After Mario Bellini) 2016

or precious as it's onto the next collection immediately – the eternal 'YES'!

Pieces of clothing in the work are unique and tailored to fit a specific person: *Brick Suit* 2010 is a unisex fit to my measurements. The things aren't always meant to be worn, and in this case there are artworks that assume the form of a kimono, for instance. The kimonos are always 'directed'; the most recent one was made for Cecil Vyse, the priggish, prudish Edwardian as played by Daniel Day-Lewis in the Merchant Ivory production of *A Room with a View*. Just as the butt is invocation of an attitude of resistance, forms, images

and materials migrate between the works and around the space. Bricks become a wool jacquard suit, model bricks at the foot of a sculpture and rendered fake wallpaper. That mania for a favoured material or theme, something so deeply appreciated that the number of different ways it manifests points to an insatiability: 'Boots! There must be boots!' It needn't matter whether they are wearable or not, made of alabaster, or tailor-made in London. The majority of works in the show are below the waist; there's a suppression of verbal expression. But everything in the work is generous for its bespoke-ness, made for a specific person,

room or the walk through that room that the visitor takes.

LY Organic materials such as food, flowers and lichens are a constant presence in your work. I wonder if you could say a little about the organic matter and its role in this exhibition?

AH The organic versus the inorganic – butt versus brick, body versus room. Binary oppositions are a flat way to discuss ideas, but they can be used as parameters. Vegetal matter needs to be replaced throughout the show. To paraphrase Duchamp, a work of art is not the same work after twenty years: the paint has

changed, as has the political and social structure around it. Organic matter hastens that change: it's not the same even three days afterwards. Perhaps changing a work from a fixed set of components into a set of ideas or actions that constitute the work creates a sensation, as well as a photo-ready image.

In the specific case of the Turner Prize exhibition, the organic matter is lichen: an algae and a fungus combining to create a hybridised life form. Lichen is most known for its extremely slow rate of growth and exceptionally diverse range of genetic expression. It is distant from our bodies in terms of time, scale

Leg Chair (John Travolta) 2010

24

and appearance, even requiring its own classification structure. Lichen here is a marker of different qualities and types of time: the grinding ache of waiting for a bus, the thrill of the ten-minute catwalk show, a sixty-hour labour, crying on an eight-hour flight to New York, a tongue-tied thirty-minute meeting with your hero, a thousand-year-old lichen sample in a museum, the perfection of eleven minutes and 57 seconds of Loose Joints' 'Is It All Over My Face'. Each of these experiences of time is as diverse, porous and unspeakable as their image may be. Formal life.

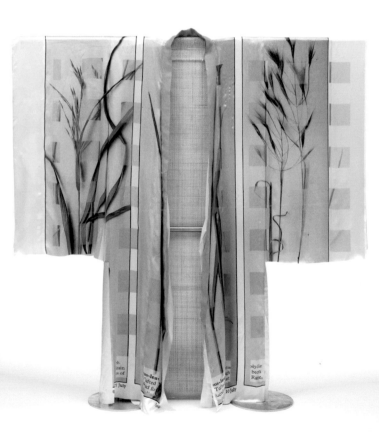

British Grasses Kimono 2015

25

HELEN MARTEN

'The longer you look at one object,
the more of the world you see in it.'[1]

Helen Marten uses sculpture, screen-printing and writing
to produce works that integrate image and object with
thought-provoking and playful intent. In her sculptures
she brings together a range of immaculately crafted
handmade and found objects drawn from contemporary
visual culture and the gestures and imagery of our
everyday lives. Her collage-like collection of these
familiar references creates poetic, pictorial puzzles
that seem to find wholly new meanings for what we
previously thought we understood.

 Through her gatherings of myriad objects and images
(cotton buds, coins, shoe soles, limes, marbles, eggs,
snooker chalk, etc) Marten invites us into a game or
riddle, sending us down a rabbit hole of associations
which she refers to as 'our vast grey milkshake of
information.'[2] With welcome candidness, Marten is
aware – and deliberately courts the danger – of using
so many contrasting visual clues. But she deftly plays
on this knife-edge, echoing certain patterns and rhythms
across her works and granting them a sense of ordered
cleanliness, so that rather than feeling overwrought,
her pieces appear to be in knowing conversation with
one another, strangely composed, shrewd and eloquent.

 Marten has written and spoken several times on the
parallel between archaeological methods of discovery
and the ways that a viewer might experience her work.

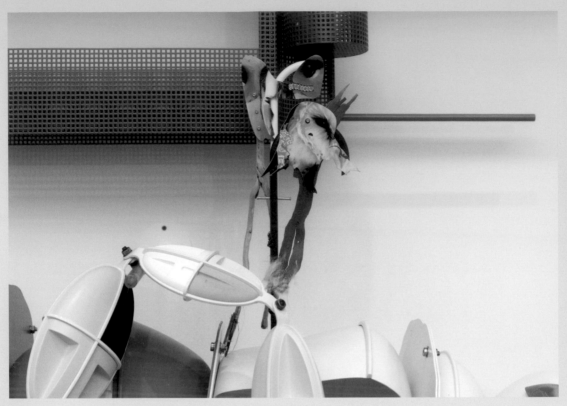

Brood and Bitter Pass (detail) 2016

It is a comparison worth considering further. When looking at one of Marten's sculptures and its many parts, each item that makes up the work seems to be seen anew, as though recovered in an archaeological dig by some future humans studying the present day in twenty, fifty or a hundred years' time. Because these future humans are not bound by the same constraints of object recognition and understanding as we are, through their eyes (or in Marten's hands) our everyday things are emptied of their familiar uses and meanings and become strange and abstract creations – 'husked down' as Marten would say, to 'geometric memories' of themselves whose meaning can be rendered afresh.

By collaging her objects and imagery, Marten collapses their recognised meanings and contexts, granting them a greater level of porosity. This allows other ideas to pass through them more fluidly, emphasising just how unstable the relationship is between the physical form of a thing and its associated meanings. That said, she does not presume that form and meaning can easily be divorced from one another; instead, the objects, things, words and images that become part of her arrangements

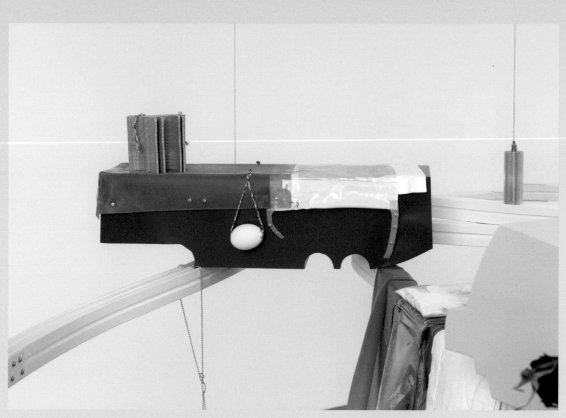

Full of frozen food (detail) 2014

carry a shadowy memory of their usual connotations. As viewers, we might hang on to the meanings that we think we know – but Marten causes them to falter in a way that is both satisfyingly curious and affirmative of their precariousness: 'There is an efficiency to the narration of familiarity, but I am always surprised how quickly representation snags and starts to break down. Something festive or luminous can quickly stagnate and become depressing. It's a turmoil of sign language, but one hinged on the established idea that a sign is a physical form, referring to something that it is not.'[3]

Like her physical works, Marten's texts and titles (*Oreo St James*; *Limpet Apology (traffic tenses)*; *Flaps, sticks, hairs and vowels*; *The cat from the bacon*) reflect and reinforce her playful logic. If Marten's objects are the treasures found in some future archaeological dig, then perhaps her texts provide a map or a diagram for the products of that digging. Aware that language has the capability to warp, alter, activate or decay the known meaning of a thing, she uses this to her advantage, applying mischievous wordplay to her titles while also asking about the 'uneasy existence between focused translation and

29

distorted projection'. In the context of her wider work, her playful, deceptive use of written language emphasises the linguistic dimension and behaviour of images and objects: if words don't look like the things they represent, what if objects didn't either? Or as Marten puts it: 'What does it mean when an image is dishonest?'[4]

For her Turner Prize presentation, Marten has included three works from the exhibitions for which she was nominated: her presentation at the 56th Venice Biennale and *Eucalyptus, Let us in* at Greene Naftali, New York. These works, made in conversation with one another, resemble workstations or sites of activity.

Everything within them looks as if it has a purpose, or as if some kind of commotion has just been interrupted. Focusing on rhythms of rest and work, the sculptures are reconceived at Tate Britain as a single installation with separate chapters that have no hierarchy. In no particular order, they consist of:

Lunar Nibs, a sculpture resembling a house, a dumpster and even a feeding trough for cattle, whose main façade looks like a caricatured nineteenth-century residence. Playing on different architectural vernaculars (Victorian housing, urban waste management, farming industry), the object's apparent

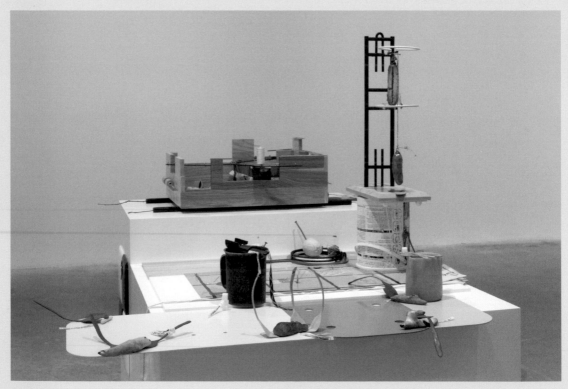

The Lemon (detail) 2016

function slips between that of a home and a site for refuse or production. Alongside, several smaller sculptural tableaux make it clear that an activity, perhaps involving chemical or alchemic exchange is, or was, taking place.

On aerial greens (haymakers) is a wall- and floor-based pairing formally resembling a fireplace or hearth, which is suggestive of the atomisation and magnification of human biology. Dislocated body parts, a pair of legs, lungs, and other bodily motifs are combined with imagery that evokes the activity of inhalation and exhalation; a puff of smoke, air, or breath is positioned alongside allusions to the bed, and to rest.

Brood and Bitter Pass, a large-scale work composed of spun aluminium forms, wooden ellipsoids, ceramic parts and mechanical joints in a serpent or worm-like form. This sculpture signals the organic, spiritual and decorative far more than its counterparts and is similar in its formal construction to Japanese *shimenawa* – giant woven knots which indicate a sacred or pure space. Here Marten suggests they might resemble a kind of 'prophylactic hoarding', or site for taking sanctuary before or after the exertion unfolding in *Lunar Nibs*.

As with Marten's practice in general, these three interlinked

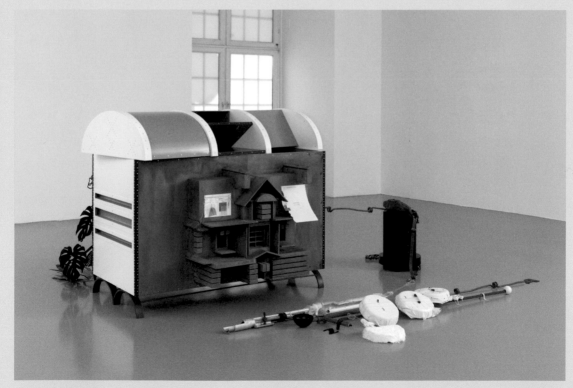

Parrot Problems 2016

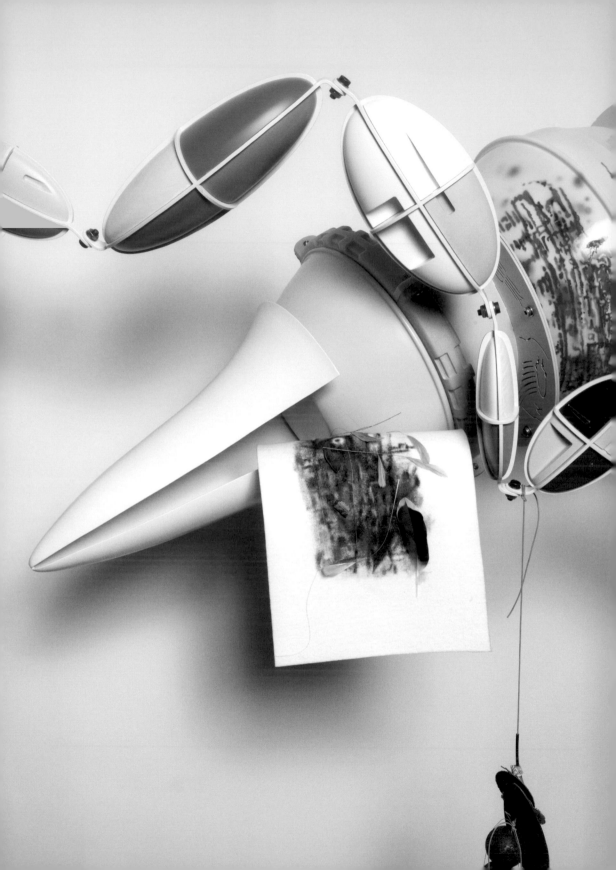

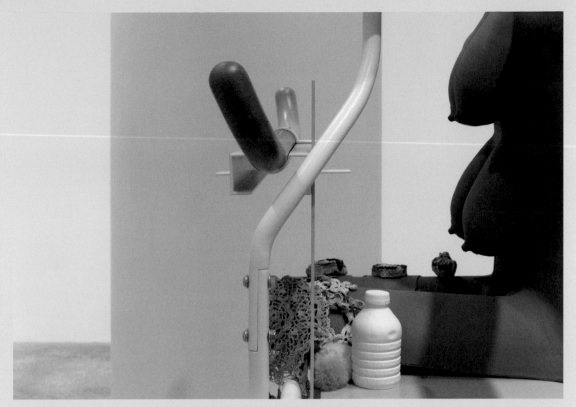

The cat from the bacon (detail) 2016

works encourage us to consider anew the materials, images and objects that surround us. Their significance cannot be located in fixed meanings and messages; instead they challenge us to decide for ourselves 'how much of an archaeologist we feel like being, how many layers we want to unearth'.[5] There is no shortcut to her works; they demand a slowed-down complexity of looking that culture today often forces us to bypass. But the rewards of that decelerated looking are many: the more you look, the more you see. An encounter with her work is akin to coming across a treasure map for an anonymous urban landscape in the not-too-distant future (or perhaps a recent but already forgotten past) containing an elaborate sequence of puzzles in a language at once familiar and alien. As Marten concludes: 'Optimistically, we've somehow queered the whole system of visual expression, so traditional binary information can be allowed a more subjectively fluid status. I love the process of dragging legibility into crisis and getting to the kernel of something where you know it, but cannot name it.'[6] LS

Opposite:
Night-blooming genera (detail) 2015

33

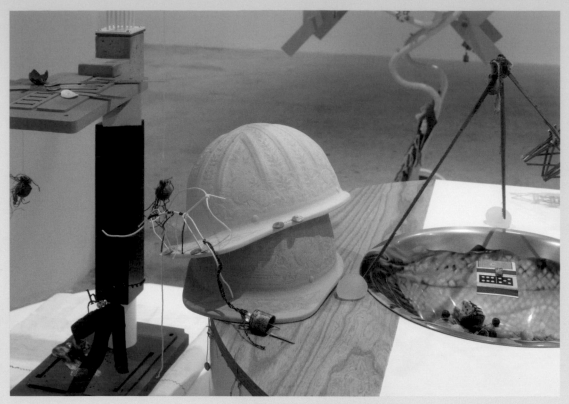

The cat from the bacon (detail) 2016

LAURA SMITH Given how multi-faceted your works are, I think it would be good to start at the beginning. I'm curious to understand the first stages of your working process. Where do your images or objects come from and how do you work with them?

HELEN MARTEN The whole process is somewhat cyclical. In terms of 'starting', I imagine this as timescale, which pre-empts the physicality of a tangible thing or image, something linguistic and more imaginary. This is my peripheral infrastructure: I'm reading, writing and generally nervous with information. I often spend several incubatory months not behaving materially, not touching anything but actively consuming content at speed. It's a spooky dialogic dance where images and their resultant baggage are not quite totalised in terms of relationships or movements with one another, but certainly not random either. This might best be described as a kind of 'laminated suspension', like having freshly printed pages before you but feeling temporarily too uninitiated to disrupt or recombine them. This beginning point is dense and vivid, but also coupled with a panic of self-exposure: it's like I'm trying to steer content,

34

but if I allow myself to concret-
ise anything at this point, to
succinctly verbalise how or what
I am trying to do, it is exactly
the moment when the idea becomes
a ghost and might vanish.

LS That sense of precarious-
ness is really interesting to me
because when I'm looking at your
work I always get the feeling
that something is on the tip of my
tongue – I am trying to understand
the whole story, but the moment
I do, it turns away from me.
How essential to you is it that
a viewer recognises the same
narrative for a work as you do?

HM I love words, so I'm also
interested in the emphatic
materiality of signs and I truly
hope that there is at least
a shred of universality in all
the works, which might allow
an external viewer to care about
them. I'm absolutely thinking
about language-ing every move,
but this process of assigning
meaning – or narrative – might
halt at some point because it
is my own projected amalgam of
code. I think rebuses propose a
similar set of obstacles: they're
visual puzzles where combinations
of pictures and single letters
constitute words. So the problem
is bound by a circumference of
logic, but inside is a soup of
potential outgoing meaning.

LS Yes! Words and language,
and how they can be used and

manipulated, are clearly as
significant to you as images and
objects. Could you talk a little
about why language is of such
importance to your work?

HM A beautiful way to think
about it is language itself as
the abstraction. Words don't
look like the things they
designate, so the reasoning
is that this might be possible –
however precariously – for images,
too. Language is how we describe
human methods of communication,
so in some way I think that the
obsessive importance I place on
it is a way for me to destabilise
our existing object-oriented
hierarchies. I could fall in love
with the aesthetic qualities of a
thing, but be equally enthralled
by its linguistic receptiveness.
And this is hilarious because
as much as we like to say things
are 'in dialogue', they are
absolutely never talking to us.
So it's a visibly masturbatory
feedback loop: there I am,
pasting my own language onto a
reflective surface and getting
off on the complimentary glow
of false exchange!

LS That enthusiasm you have for
language can definitely be seen
in your approach to materials
as well. You seem to be able to
employ such a range of different
materials with ease – in terms
of understanding both their
physical properties and their
potential metaphorical ones.

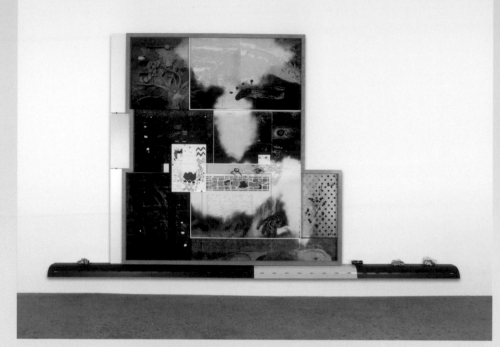

Limpet Apology (traffic renses) 2016

Knockoff Venus (detail) 2016

Could you talk about the specific roles that certain materials have for you?

HM Anybody who has ever handled a sponge understands that it might be capable of soaking up liquid. That is our haptic power; we're lucky to be optically evolved enough to predict sensation. So the treachery in my work might be a simulation of authority, a willingness to bastardise substance and ask it to behave in numerous unexpected ways. Even a simple nod towards a shape or material that might be reminiscent of a pre-existing form is quite literally a vocaliser of external things – an agent of the world outside art-making. And this is the point where you can use recognisable authority, the obstinate fact of a universally existent thing – an arm, a teapot, an alphabet – and extricate it from its own sense of intentionality. Artists can exploit a materialist history of stuff and render it – and by render, I mean almost in the culinary sense of breaking down, melting the fat – and reform it anew.

LS You are nominated for the Turner Prize for your presentation at the Venice Biennale in 2015 and *Eucalyptus, Let us in* at Greene Naftali, New York, and you are showing a trio of works from both of those shows. I wonder if you could talk a little about these works?

HM The work is conceived around an architectural structure – in this case, two intersecting walls – setting out a kind of algorithmic space. By algorithmic, I mean a logic of exchange (both formally and metaphorically) where you encounter repetitions, additions or subtractions enabled by the possibility to move around and through the works. These 'sequences' are rotational, and could be encountered in any order: there is no back or front. The works plot out various tangential ideas of rest versus labour time, and how the memory of a human form or pattern of behaviour might become remnant to something more mechanised or biomorphic. Conceptually, they could be thought of as host, guest or parasite; architecturally they might represent a workplace, fireside and façade. In many ways, these works follow the concept of the model as a basic means of organisation and are underscored by an interest in the point at which diagrammatic clarity – a recognisable model or paradigm – breaks down, as though wilted through a process of collaged abstraction. Scale is treacherous and, contrary to the micro-analytical scale of some details, numerous image references carry ideas about the complexity but automatised activity of inhalation and the metaphors of substance and atomisation attached: the atomic is exploded into something huge and unruly.

JOSEPHINE PRYDE

Artist biographies and essays often begin with a concise list of the mediums that the artist utilises: photography, performance, sculpture, writing. It's a device to set the ground and invite the audience to begin piecing together what you are being asked to look at and to locate it both within a wider art-historical narrative and within the room in which you are standing. Josephine Pryde has, at one time or another over the past twenty-five years, worked to a greater or lesser extent across all of the mediums listed above. However, photography is at the heart of her practice, and with each presentation, the relationship between the photographic image and the object-based works around it shifts.

For this Turner Prize 2016 exhibition held at Tate Britain, Pryde is showing a number of framed photographs and a miniature train, alongside a new series of works, which will be installed leaning down one wall.

Pryde's work often draws on her consideration of the mechanisms of cultural production: the status of artwork, the use of technology in communicating knowledge, and the position of women within society. When working with photography she tends to work in series, rather than individual images, often repeating variations on a theme, as if for an ongoing imaginary magazine spread. *Hands (Für Mich)* (2014 – ongoing) is one such series: this body of photographs (currently totalling forty-six individual works) depicts manicured hands holding objects such as iPhones, pens, driftwood, and Christmas gifts given to the artist by two of the

galleries that represent her commercially. These works deliberately echo certain compositional devices often found in advertising or fashion photography: the lens focuses on where hand and object touch, framing them close to the torso, looking for new gestures and points of contact.

Previous series have had a more explicit relationship to fashion and its visual language such as the works shown in the 2010 exhibitions *Therapie Thank You* and *Therapie Thank You Thank You*, where she photographed in close-up a mechanically pleated fabric, creating the impression that it was draped over the body of a woman; *Scale* 2012, a series of playfully styled shots of guinea pigs, and *This Time Last Year* 2012, a series of photographs of stylish women, shop workers and security staff taking part in a late night shopping event in London's West End. This use of the tropes of advertising and fashion relates to Pryde's interest in the psychology of contemporary capitalism and what critic Juliane Rebentisch has described as the 'entanglements of art and visual mass culture'.[1]

There is a selection of new works in this Turner Prize 2016 exhibition, titled *Summer of 2016 (London, Athens, Berlin)*. Each records the action of light on the reverse side of a kitchen worktop, a product available identically and internationally through a

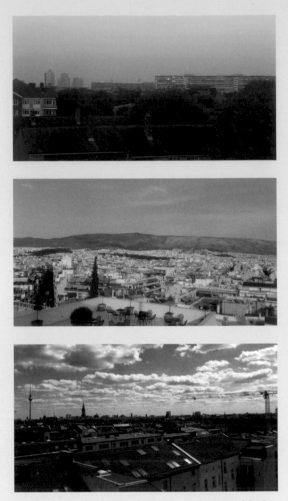

From top: *London, Athens, Berlin* 2016

furniture store for use in fitted kitchens. How do these works fit here? They might speak of photography in that they display the results of the effect of light over time through judicious use of templates laid on their surfaces. They might speak of minimalist sculpture in that the elements are repeated and of the same size. Their rectangular shape and dimensions echo the shape of the railway sleepers on the train track nearby, perhaps, and they

40

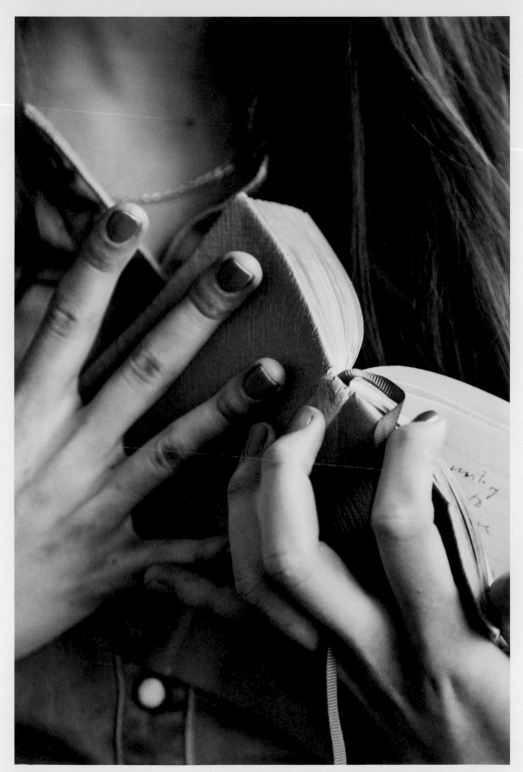

Gift For Me, Simon Lee Gallery Christmas 2013 (1) 2015

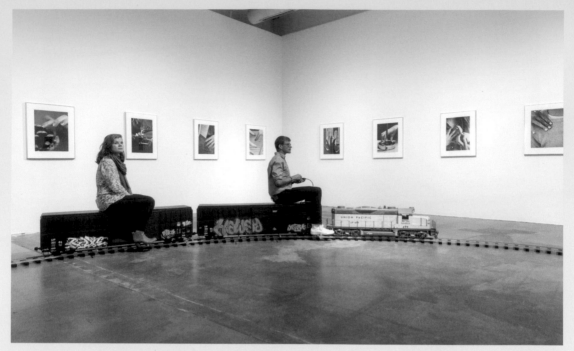

lapses in Thinking By the person i Am, installation view,
Institute of Contemporary Art, University of Pennsylvania 2015

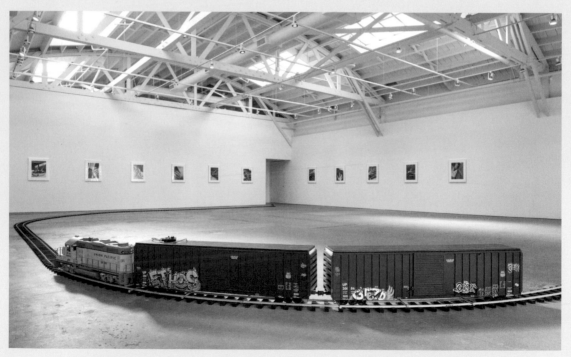

lapses in Thinking By the person i Am, installation view,
CCA Wattis Institute for Contemporary Arts, San Francisco 2015

are leaning against the wall, rather than hung, lending them a provisional air, as if stacked in a goods yard.

The miniature train, however, carries more definite traits. *The New Media Express* is a five-inch gauge scale model of a Class 66 diesel locomotive in the DB Schenker livery pulling two MK1 (Mark 1) carriages in British Rail blue and grey livery. The full size Class 66 remains in use today, but the MK1 carriages are no longer in service. So the model combines, after discussion between fabricator and artist, elements that both an older and a younger audience might recognise. *The New Media Express* was first exhibited in the solo show *These Are Just Things I Say, They Are Not My Opinions* at Arnolfini gallery, Bristol, and again as part of the 9th Berlin Biennale in 2016 (a different model of train was used in the exhibition *lapses in Thinking By the person i Am* at CCA Wattis Institute for Contemporary Arts, in San Francisco, for which Pryde was nominated for the Turner Prize). Each time, graffiti has been added to it. Adding the graffiti means that the train is on one level taken to a further stage of realism in its scale modelling, beyond its spanking new model train livery; it also distinguishes it from a box-fresh type of readymade artwork. The additional painting or writing on its sides is done by a graffiti artist, in consultation with the artist. The writing further adapts Pryde's interest in spoken and written language, which runs throughout these two previous exhibitions – for example, in the titles of the shows, or in the words appearing on t-shirts or screens in the photographs. The phrase 'The train drives through the tunnel' has been graffitied in Cantonese on the guard's carriage on the train that is presented at Tate Britain, a 'tag' that was added for its display at the Feuerle Collection – a private collection of Southeast Asian art and Chinese design – as part of the 9th Berlin Biennale. At Tate Pryde has retitled the work *The New Media Express in a Temporary Siding (Baby Wants To Ride)*.

The three bodies of work in this exhibition – the photographs of hands, sun-bleached boards and the train – are all works that unfold and change over time, in parallel with the ever evolving socio-political context of the work. This begs various questions of art's changing relationship with culture and society: how does the proliferation of high-quality digital cameras on devices such as smart phones affect our understanding of photography? What do we understand by participation as part of our experience of art? And how does the increasing professionalisation of the art world affect the way in which we read an artwork? LY

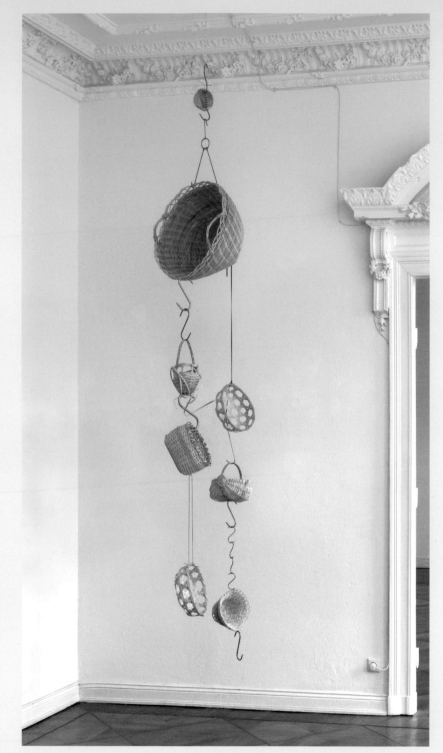

Therapie Thank You Thank You,
installation view, MD 72, Berlin 2010–2011

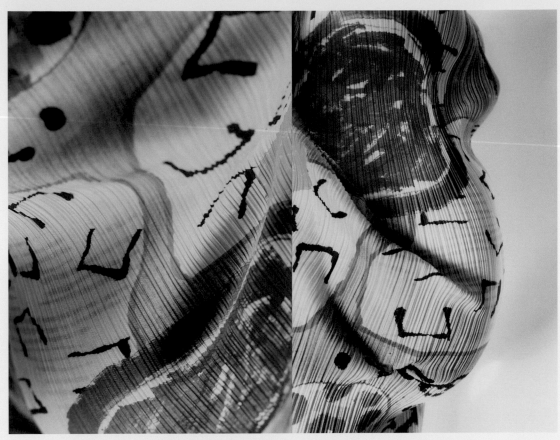

Do You Want Children 2010

LINSEY YOUNG We ask that artists nominated for the Turner Prize show the work they were nominated for wherever possible and you are doing that, showing the train and the series of framed photographs that were included in *lapses in Thinking By the person i Am* at CCA Wattis, but we also spoke about new work being included. Could you tell me about what form that work might take?

JOSEPHINE PRYDE Initially I thought my part of the Turner Prize show could simply consist of those two elements running in parallel, as they had been combined several times before – the hand photographs on the wall, with a miniature train alongside. Deal. But gradually, I realised I wanted to prise those elements apart a bit, and to try to reassemble the dynamics. I happened to glimpse from an elevated walkway some wood offcuts left by recycling bins, and had the idea to attempt to recreate what I saw in them as artworks. Leaving wood-based material in the sun. You could say these new pieces involve both an expanded and contracted notion of photography. Expanded,

45

in as much as image making is not happening through a lens for reproduction on a screen or special paper, and contracted in that it's not an original idea, by any stretch of the imagination, to contrive a way to record the action of light over time and display the results.

LY Much of your photographic work is highly stylised and glamorous, I'm thinking particularly of series such as *Scale* with its guinea pig models or *This Time Last Year* that documents a high-end late night shopping event in London. These photographs are often countered with objects that are much more humble – for example, the woven baskets in the 2010 exhibitions *Therapie Thank You and Therapie Thank You Thank You*. I'm interested in how you work between sculpture and photography, mediums that I think a lot of people would see as being quite separate.

JP This question of style and glamour remains a knotty one! I mean, you could say all our photos on Instagram are stylised and glamorous, as well as magazine and advertising shoots. I don't think of how I make the photographs as being about styling or glamorising in the first instance. I'm interested in observation first. If you look at the guinea pig photos, the various props and elements in the shot are there to expand the scene a little, to create a landscape, and the

guinea pigs are never dressed up or groomed in any way. The idea was not exactly to transform the humble guinea pigs into fashion stars. They are also rodents, however cuddly, and frequently kept as domestic pets, while late night shopping remains late night shopping, however hard the public relations teams may try and transform it into an inspiring, creative, IRL ['In Real Life'] event... Those attributes should sit in the images somewhere, too.

LY The titles of your works are very important and there are often additional elements of text, either in the form of wall vinyl or perhaps the writing on clothing in photographs. What role does language play in the work?

JP There is a phrase in German: *Es geht nicht ohne* – 'It doesn't work without it'. It isn't so much that language plays a role, it's part of it. A root of the word 'photographic' is 'graphic' – writing, not just drawing. It comes along with the practice in my case – through the inclusion of signs and letters in images and objects, or through texts I produce, or the notations necessary to remember anything at all in the first place.

LY In this presentation of *The New Media Express* the train will not be running in the usual way. Visitors will still be able to see the work move on its tracks

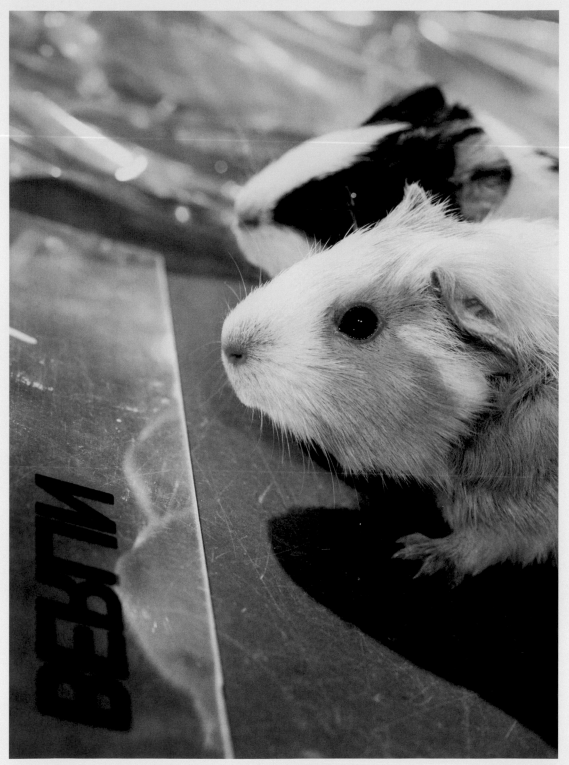

Scale XIII 2012

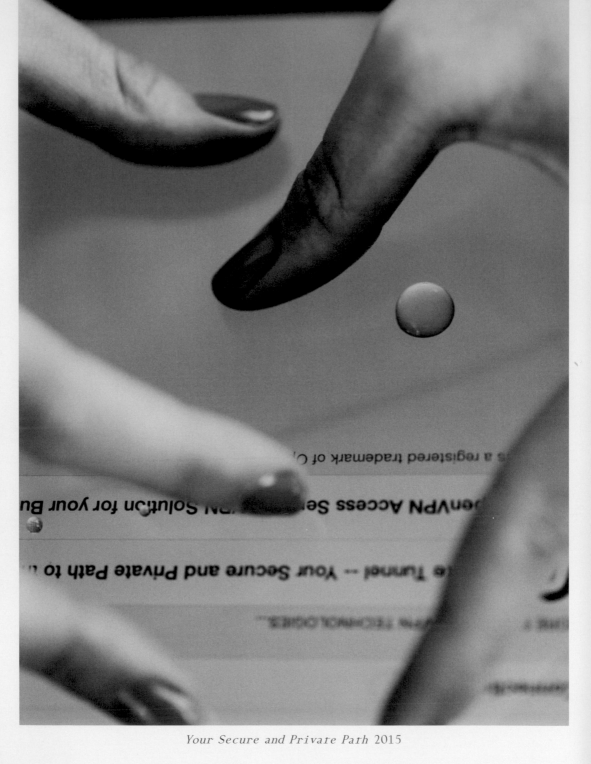

Your Secure and Private Path 2015

but they won't be able to engage with it physically. Could you talk a little about that decision and the effect that the institution of Tate has had on this presentation?

JP It's interesting that you didn't immediately include vision as part of physical engagement. The two miniature, rideable five-inch gauge trains that I produced were in part a (very) delayed response to the canonisation of a type of art that is sometimes called 'participatory'. Art where an audience is encouraged to 'get involved', like with Carsten Höller's slide pieces. But being driven as a passenger on a miniature train through an art exhibition could also be seen as somewhat infantilising, even if it does offer you an alternative experience to walking round the gallery or museum. I think *The New Media Express* has reached a temporary siding, now that it is to be displayed as part of the Turner Prize exhibition. The train has worked hard in previous installations in Bristol and Berlin, carrying the exhibitions' visitors back and forward through those spaces, and I wanted to explore resting the piece – to step back for a moment from the imperative to expand, or promote a visitor's on-board experience as the key to unlock the imagination.

LY Several images from your recent series of photographs of hands have titles like *Für Mich* (For Me), or variants on this phrase. Why did you choose these?

JP I have been working in tertiary level art teaching for over a decade. I have frequently been in a situation where I am asked to judge the work of other artists, usually young artists, either for examinations or prizes or for entrance to the art school. Invariably, a question about motivation may arise. How to judge motivation? Sometimes when confronted with such a loaded question, candidates may sensibly suggest they are pursuing art for themselves. This could be a prudent hedge under pressure, or it could be the belief they hold to be most true at the time. It's two years since I was last on an examination panel, and since then I have been thinking on and off about this answer 'for myself', and my preconceptions about it, and how they, and the contexts, are changing. The hands that I photograph for this series in some senses come to stand in for a self. I'm directing the camera towards the point of articulation between the hand and a device held by that hand, imagining locating a new joint growing in the body. This can include the hand that touches its own chest, identifying itself in the gesture, while the attendant head is out of the picture. It's the beginnings of compiling a rudimentary, forever incomplete lexicon of these gestures, perhaps.

Michael Dean was born in Newcastle upon Tyne in 1977. He studied at Goldsmiths College, London. His forthcoming solo show *Sightings: Michael Dean* at The Nasher Sculpture Center, Dallas, USA opens in October 2016. Recent solo exhibitions include: *Sic Glyphs*, South London Gallery, London, UK (2016); *Qualities of Violence*, de Appel arts centre, Amsterdam, Netherlands (2015); *Jumping Bones*, Extra City Kunsthal Antwerp, Antwerp, Belgium (2015); *HA HA HA HA HA HA*, Kunst Forum Ludwig, Aachen, Germany (2014); *The Introduction of Muscle*, Arnolfini, Bristol, UK (2014); *thoughts*, Cubitt, London, UK (2012); *Government*, Henry Moore Institute, Leeds, UK (2012); *State of being apart in space*, Kunstverein Freiburg, Germany (2011); *Acts of Grass*, Serpentine Gallery Pavilion, London, UK (2011). His performance *Acts of Grass* 2012 was presented at the Serpentine Pavilion as part of the gallery's Park Nights series. In 2014 he was the recipient of a Paul Hamlyn Foundation Award for Artists. Selected group exhibitions include: *The Language of Things*, Public Art Fund – City Hall Park, New York, USA (2016); *Par tibi, Roma, nihil*, Nomas Foundation, Rome, Italy (2016); *Albert the Kid Is Ghosting*, The David Roberts Art Foundation, London, UK (2015); *Sculptures Also Die*, curated by Lorenzo Benedetti, CCC Strozzina, Florence, Italy (2015);

The Noing Uv It, Bergen Kunsthall, Bergen, Norway (2014); *What is Real*, curated by Stephanie Rosenthal, The Hayward Gallery, London, UK (2014); *MIRRORCITY*, curated by Stephanie Rosenthal, The Hayward Gallery, London, UK (2014); *A History of Inspiration*, curated by Adnan Lyildiz, Palais de Tokyo, Paris, France (2013); *A Dying Artist*, Institute of Contemporary Arts, London, UK (2011); *We Will Live, We Will See*, curated by Pavel S. Pys, Zabludowicz Collection, London, UK (2011).

LIST OF WORKS

Title of Installation:
Sic Glyphs

At the time of print Dean's final list of works was still in production. His presentation includes works from both *Sic Glyphs* at South London Gallery 2016 and *Qualities of Violence* at de Appel arts centre, Amsterdam 2015.

Anthea Hamilton was born in London in 1978. She studied at Leeds Metropolitan University and the Royal College of Art, London. Her solo exhibitions and performances include: *LOVE IV: COLD SHOWER* (with Nicholas Byrne), Schinkel Pavillion, Berlin, Germany (2016); *Lichen! Libido! Chastity!* SculptureCenter, New York, USA (2015); *House*, Oslo, Norway (2015); *LET'S GO*, Bloomberg SPACE, London, UK (2013); *Sorry I'm Late*, Firstsite, Colchester, UK (2012); *Kabuki, Performance Year Zero*, The Tanks, Tate Modern, London, UK (2012); *LOVE* (with Nicholas Byrne), Frieze Projects East, London, UK (2012); *Open Set*, IBID Projects, London, UK (2011); *Gymnasium*, Chisenhale Gallery, London, UK (2008); *Cut-Outs*, Galerie Fons Welters, Amsterdam (2007). She has participated in numerous group exhibitions, most recently: *British Art Show 8*, Leeds Art Gallery and touring (2015–17); *Chance Encounters*, LOEWE Foundation, Miami, USA (2015–16); *La Vie Moderne*, 13th Biennale de Lyon, Lyon, France (2016); *TERRAPOLIS*, NEON and the Whitechapel Gallery, Ecole de Française d'Athens, Athens, Greece (2015); 10th Gwangju Biennale: *Burning Down the House*, Gwangju, South Korea (2014); *Notes on Neo-Camp*, Studio Voltaire, London, UK (2013).

LIST OF WORKS

Title of Installation:
Lichen! Libido! (London!) Chastity!

At the time of print Hamilton's final list of works was still in production. It includes:

Project for a Door (After Gaetano Pesce) 2016
Open cell, polyurethane foam, epoxy, paint, board, wallpaper
604 × 480

Brick Suit 2010
Wool, lining material
116.8 × 55.9 × 12.7

Big Pants Chastity Belt 2015
Rubber, steel, glass, galvanised zipper fixing
33 × 25.4 × 30.5

1st Guimard Chastity Belt 2015
Stainless steel, galvanised steel, leather
40.6 × 17.8 × 35.6

2nd Guimard Chastity Belt 2015
Stainless steel, galvanised steel
40.6 × 17.8 × 35.6

Thigh High Hairy Boot 2016
Leather, fabric, glass, metal
97 × 27 × 12

HELEN MARTEN

Helen Marten was born in Macclesfield in 1985. She studied at Central Saint Martins, London and Ruskin School of Fine Art, University of Oxford. Her solo exhibitions include: *Eucalyptus, Let us in*, Greene Naftali Gallery, New York, USA (2016); *Orchids, or a hemispherical bottom*, König Galerie, Berlin, Germany (2014); *Parrot Problems*, Fridericianum, Kassel, Germany (2014); *Oreo St. James*, Sadie Coles HQ, London, UK (2014); *No Borders in a wok that can't be crossed*, CCS Bard Hessel Museum, New York, USA (2013); *Plank Salad*, Chisenhale Gallery, London, UK (2012); *Evian Disease*, Palais de Tokyo, Paris, France (2012); *Almost the exact shape of Florida*, Kunsthalle Zürich, Zürich, Switzerland (2012); *Dust and Piranhas*, Park Night Project, Serpentine Gallery, London, UK (2011); *Take a stick and make it sharp*, Johann König, Berlin, Germany (2011); *Wicked Patterns*, T293, Naples, Italy (2010). Her forthcoming solo exhibition at the Serpentine Sackler Galleries, London opens in September 2016. Selected group exhibitions include: *Hepworth Sculpture Prize*, Hepworth Wakefield, UK (2016); *The future is already here – it's just not evenly distributed*, 20th Biennale of Sydney, Australia (2016); *All the World's Futures*, 56th International Art Exhibition, Venice Biennale, Venice, Italy (2015); *MIRRORCITY: 23 London Artists*, The Hayward Gallery, London, UK (2014);

The 12th Lyon Biennale, Lyon, France (2013); *Il Palazzo Enciclopedico (The Encyclopaedic Palace)*, 55th International Art Exhibition, Venice Biennale, Venice, Italy (2013).

LIST OF WORKS

Brood and Bitter Pass 2016
Steel, aluminium, hand-thrown glazed ceramic, airbrushed steel, model board, maple, walnut, fur, cast resin, cast Jesmonite, stitched fabric, brass, xenophora shell, oyster shell, stitched and embroidered fabric, burnt Fimo, glass, model trees, recycled paper, clay, ribbon, chipboard, painted polyurethane, sequins
301 × 111.8 × 816.9

Lunar Nibs 2015
Welded steel, aluminium, stitched fabric, lacquered chipboard, string, cast plaster, cast rubber, cast resin, nails, copper sulphate, clay, bones, black sand, etched steel, cut vinyl, snakeskin, fish skin, copper wire, hand-thrown glazed ceramic, coins, felt, taxidermy insects, salt
139.5 × 323 × 202

On aerial greens (haymakers) 2015
Part 1: Lacquered hardwood, steel, shoe soles, rubber, cast resin, stitched fabric, pipe tubing, galvanised cardboard, string, stamped baking paper, limes, marbles, embroidered fabric
Part 2: Screen-printed suede, leather and PVC, hand-thrown glazed ceramic, lacquered hardwood, Formica, cast resin, cast rubber, woven straw
233.3 × 458.4 × 46.9

Josephine Pryde was born in 1967 in Alnwick, Northumberland, UK. She studied at Wimbledon School of Art, London and later at Central Saint Martins, London. Her selected solo exhibitions include: *lapses in Thinking By the person i Am*, CCA Wattis Institute for Contemporary Arts, San Francisco, USA and Institute of Contemporary Art, University of Pennsylvania, Philadelphia, USA (2015); *These Are Just Things I Say, They Are Not My Opinions*, Arnolfini, Bristol, UK (2014); *Knickers, Berlin*, Temnikova & Kasela, Tallinn, Estonia (2014); *Photographs You Take*, THE SCHTIP, Sheffield, UK (2013); *Night Out*, Simon Lee Gallery, London, UK (2012); *Miss Austen Enjoys Photography*, Kunstverein Düsseldorf, Germany (2012); *Miss Austen Still Enjoys Photography*, Kunsthalle Bern, Bern, Switzerland (2012); *Embryos and Estate Agents: L'Art de Vivre*, Chisenhale Gallery, London, UK (2012); *Therapie Thank You*, Reena Spaulings Fine Art, New York, USA (2010); *Therapie Thank You Thank You*, MD 72, Berlin, Germany (2010); *Valerie*, Secession, Vienna, Austria (2004); *Brains & Chains*, Cubitt, London, UK (2004). Selected group exhibitions include: 9th Berlin Biennale, Berlin, Germany (2016); *Collected by Thea Westreich Wagner and Ethan Wagner*, Whitney Museum of American Art, New York, USA and Centre Pompidou, Musée national d'art moderne, Paris, France

(2016); *I, you, he / she / it*, Kunstverein Leipzig, Germany (2016); *The Day Will Come When Photography Revises*, Kunstverein Hamburg, Hamburg, Germany (2015); *New Photography 2013: Adam Broomberg and Oliver Chanarin, Brendan Fowler, Annette Kelm, Lisa Oppenheim, Anna Ostoya, Josephine Pryde, Eileen Quinlan*, MoMA, New York, USA (2013).

Josephine Pryde is currently Professor for Contemporary Art and Photography at the University of the Arts, Berlin.

LIST OF WORKS

Summer of 2016 (London, Athens, Berlin) 2016
Solid beech wood, particle board and MDF with paper backing
Each: 193 × 65 × 5

The New Media Express in a Temporary Siding (Baby Wants To Ride) 2014/2016
Miniature 5-inch gauge passenger locomotive with two carriages. Built from laser-cut and powder coated mild steel, with MDF, batteries, electrical components, paint and vinyl, mounted on a platform.
Locomotive:
34.9 × 23.5 × 189.2
Two coaches, each:
35.6 × 23.5 × 193
Overall: 35.6 × 23.5 × 590.5
Platform: 1100 × 11 × 52

Aufnahmeprüfung 2 2016
C-print
79.2 × 62.7

For Myself 3 2016
C-print
79.2 × 62.7

Dimmable Lights Level 2 2014
C-print
79.2 × 62.7

A Cone 2015
C-print
79.2 × 62.7

Here Do You Want To 2014
Giclée print
79.2 × 57.7

For Myself 2 2014
C-print
79.2 × 62.7

A Friend 2015
C-print
79.2 × 62.7

Für Mich 3 2016
C-print
79.2 × 62.7

Who Were You? 2016
C-print
79.2 × 62.7

Gift Für Mich, Galerie Neu Christmas 2014 (1) 2015
C-print
79.2 × 62.7

Gift For Me, Simon Lee Gallery Christmas 2013 (1) 2015
Giclée print
79.2 × 57.7

Camera 2016
C-print
79.2 × 62.7

Your Secure and Private Path 2015
C-print
79.2 × 62.7

Sorry Not Sorry 2016
C-print
79.2 × 62.7

Für Mich 2 2014
C-print
79.2 × 62.7

FOOTNOTES

MICHAEL DEAN

1. Michael Dean,
November to November,
self-published, 2008
2. Michael Dean, quoted
in *Sic Glyphs*, exh. cat.,
South London Gallery,
18 March – 22 May 2016

ANTHEA HAMILTON

1. Sergio Rigoletto,
*Masculinity and Italian
Cinema: Sexual Politics,
Social Conflict and Male
Crisis in the 1970s*,
Edinburgh University Press,
Edinburgh 2014, p.102
2. 13 March 1975. Pier
Pasolini, *Lutheran Letters*,
Carcanet Press, New York
1987, p.19
3. Ruba Katrib, 'Anthea
Hamilton: Shapewear,
underwear', *Anthea Hamilton:
Lichen! Libido! Chastity!*,
exh. cat., p.3
4. In conversation with
Linsey Young, 6 July 2016
5. Cecilia Alemani, text
for Frieze Projects New
York, Randall's Island,
New York 2016

HELEN MARTEN

1. Flannery O'Connor,
*Mystery and Manners:
Occasional Prose*, Farrar,
Straus and Giroux, New York
1969, p.77
2. Helen Marten, *Eucalyptus,
Let us in press release*,
Greene Naftali Gallery,
New York, 15 January –
25 February 2015
3. Helen Marten, 'Pronounced
with rocks in the mouth (or,
an object ignites, it was
thought, according to the
form of its name)',
conversation with Susanne
Pfeffer, in *Parrot Problems*,
Koenig Books, Köln 2016
4. Ibid.
5. Ibid.
6. Ibid.

JOSEPHINE PRYDE

1. Juliane Rebentisch,
Texte zur Kunst, No.100,
December 2015, p.62

CREDITS

2. Photo: Michael Dean
5. Courtesy de Appel arts
centre, Amsterdam; Herald
St, London. Photos:
Ken Adlard
6. Courtesy de Appel arts
centre, Amsterdam; Herald
St, London. Photo: Cassander
Eefrinck Schattenkerk
7. Courtesy Herald St,
London. Photo: Ken Adlard
8-10. Courtesy South London
Gallery, London; Herald St,
London. Photo: Andy Keate
12. Courtesy de Appel arts
centre, Amsterdam; Herald
St, London. Photos:
Ken Adlard
15. Photo: Valerie Sadoun
16-20. Photos: Kyle Knodell
23. Commissioned and
produced by Frieze Art
Inc. for Frieze New York
Projects 2016. Photo:
Timothy Schenck. Courtesy
Frieze Art Inc.
24. Photo: Andy Keate
25. Courtesy the artist
and LOEWE Foundation.
Photo: Lewis Ronald
26. Photo: Juergen Teller
28-36. © The Artist,
courtesy Sadie Coles HQ,
London; Greene Naftali,
New York; Köenig Galerie,
Berlin; T293, Rome and
Naples. Photo: Annik
Wetter, Geneva
39. Photo: Dan Mitchell
40. Photos: Josephine Pryde
(top and middle); Marius
Glauer (bottom)
41. Courtesy of the artist
and Galerie Neu, Berlin;
Reena Spaulings Fine Art,
New York/Los Angeles
and Simon Lee Gallery,
London/Hong Kong. Photo:
Johnna Arnold
42. Courtesy of the artist
and The Institute of
Contemporary Art, University
of Pennsylvania, PA. Photo:
Constance Mensh (top);

Courtesy of the artist
and CCA Wattis Institute
for Contemporary Arts,
San Francisco, CA. Photo:
Johnna Arnold (bottom)
44. Courtesy of the artist
and Galerie Neu/MD 72, Berlin
45. Courtesy of the artist
and Reena Spaulings Fine Art,
New York/Los Angeles. Photo:
Farzad Owrang
47. Courtesy of the artist
and Galerie Neu, Berlin;
Reena Spaulings Fine Art,
New York/Los Angeles
and Simon Lee Gallery,
London/Hong Kong. Photo:
Jürgen Staack
48. Courtesy of the artist
and Galerie Neu, Berlin;
Reena Spaulings Fine Art,
New York/Los Angeles
and Simon Lee Gallery,
London/Hong Kong. Photo:
Johnna Arnold

PREVIOUS WINNERS

2015	Assemble
2014	Duncan Campbell
2013	Laure Prouvost
2012	Elizabeth Price
2011	Martin Boyce
2010	Susan Philipsz
2009	Richard Wright
2008	Mark Leckey
2007	Mark Wallinger
2006	Tomma Abts
2005	Simon Starling
2004	Jeremy Deller
2003	Grayson Perry
2002	Keith Tyson
2001	Martin Creed
2000	Wolfgang Tillmans
1999	Steve McQueen
1998	Chris Ofili
1997	Gillian Wearing
1996	Douglas Gorden
1995	Damien Hirst
1994	Antony Gormley
1993	Rachel Whiteread
1992	Grenville Davey
1991	Anish Kapoor
1990	Prize suspended
1989	Richard Long
1988	Tony Cragg
1987	Richard Deacon
1986	Gilbert & George
1985	Howard Hodgkin
1984	Malcolm Morley

TURNER PRIZE 2016 JURY

Michelle Cotton
Director,
Bonner Kunstverein, Bonn

Tamsin Dillon
Independent Curator

Beatrix Ruf
Director,
Stedelijk Museum, Amsterdam

Simon Wallis
Director,
The Hepworth Wakefield

The Turner Prize will be
awarded at Tate Britain on
5 December 2016, to an artist
under fifty, born, living
or working in Britain, for
an outstanding exhibition
or other presentation of work
in the twelve months prior to
April 2016. The announcement
will be broadcast on the BBC.

Published 2016 by order
of the Tate Trustees on the
occasion of the exhibition
at Tate Britain, 27 September
2016 – 2 January 2017

by Tate Publishing,
a division of Tate
Enterprises Ltd, Millbank,
London SW1P 4RG

www.tate.org.uk/publishing

Written by Laura Smith
and Linsey Young
(Tate Curators)

Designed by Stephen Barrett

Printed by PUSH

Measurements are given in
centimetres, height before
width and depth

This exhibition has been
made possible by the
provision of insurance
through the Government
Indemnity Scheme. Tate would
like to thank HM Government
for providing Government
Indemnity and the Department
for Culture, Media and Sport
and Arts Council England
for arranging this.

Acknowledgements
With thanks to Michael
Dean, Anthea Hamilton,
Helen Marten and Josephine
Pryde, and also to: Colour
flooring; Dwell; Galerie
Neu, Berlin; Geo Fleur;
Greene Naftali, New York;
Haro Press; Herald St,
London; Köenig Galerie,
Berlin; Andreas Melas;
Mendes Wood DM, São Paulo;
Helena Papadopolous; Reena
Spaulings Fine Art, New
York/Los Angeles; Sadie
Coles HQ, London; Simon
Lee Gallery, London;
Supportico Lopez, Berlin
and Valeria Napoleone.

FSC
FSC Printer
Cert no. SGS-COC-004556

EXCAT